Ruth Weisberg

Ruth Weisberg

Paintings
Drawings
Prints

1968 – 1988

Curated by Marion E. Jackson

With essays by
Thalia Gouma-Peterson
Marion E. Jackson

The University of Michigan
School of Art
Ann Arbor, Michigan

The Feminist Press
at The City University of New York
New York, New York

Itinerary of the Exhibition

Jean Paul Slusser Gallery
The University of Michigan School of Art
Ann Arbor, Michigan
March 9—April 3, 1988

DePree Art Center and Gallery
Hope College
Holland, Michigan
May 29—July 5, 1988

College of Wooster Art Museum
Wooster, Ohio
August 24—October 16, 1988

Laguna Art Museum
Laguna Beach, California
November 11, 1988—January 8, 1989

Associated American Artists, New York, New York

Sandy and Adrea Bettelman, Beverly Hills, California

The Art Institute of Chicago, Chicago, Illinois

Robyn Dawes and Mary Schafer, Pittsburgh, Pennsylvania

Barbara Eldersveld, Ann Arbor, Michigan

Karl and Gloria Frankena, Ann Arbor, Michigan

Naomi Weisberg Gottlieb, Ann Arbor, Michigan

Grand Rapids Art Museum, Grand Rapids, Michigan

Jon Levine, San Francisco, California

Myron and Bobbie Levine, Ann Arbor, Michigan

The University of Michigan Museum of Art, Ann Arbor, Michigan

Ruth Nash, Larkspur, California

Portland Art Museum, Portland, Oregon

Robert and Jan Richter, San Francisco, California

Lisa Welborn Russell, Los Angeles, California

Jack Rutberg Fine Arts, Los Angeles, California

Gary and Brenda Ruttenberg, Los Angeles, California

David and Janet Schein, Los Angeles, California

Alice Simsar Gallery, Ann Arbor, Michigan

Theresa Weisberg, Los Angeles, California

Josephine Withers, Washington, D.C.

Patricia Goldring Zukow, Sherman Oaks, California

Acknowledgements

An art exhibition on this scale is possible only through the dedicated work and generous cooperation of countless individuals. On behalf of the University of Michigan School of Art, I would like to thank all the lenders who have parted with treasured works of art for a period of more than a year in order that others might see and enjoy them. I particularly thank Ruth Weisberg's gallery representatives—Jack Rutberg, Alice Simsar, and Robert Conway—all of whom not only loaned works to the exhibition, but also assisted in many ways throughout all stages of planning and organizing. The exhibition is well-served by Dr. Thalia Gouma-Peterson's perceptive catalogue essay on Ruth Weisberg's recent work, and I thank her for this important contribution. I am grateful as well to Laura Clemente, B.F.A. '86, who designed and coordinated the production of this catalogue, printmaker Efram Wolfe, who worked with Ruth Weisberg to produce her new print associated with this exhibition, and to Naomi Weisberg Gottlieb, whose interest and efforts to aid this exhibition have taken many forms.

Within the School of Art, many individuals have devoted a great amount of energy and talent to the exhibition and catalogue. Primary among these are Joyce Watson, who coordinated the complexities of procuring and shipping all works and the exhibition's national tour; Carol Shannon, who patiently and thoughtfully edited the catalogue text and coordinated public relations; Joan Susskind, who provided secretarial support for the entire project and offered countless helpful suggestions; and Bruce Ian Meader, who provided oversight and guidance on matters of design. Other staff members who worked directly on this project include Chris Grandel, Linda Bachrach, and Marc Krecic.

Behind this staff effort is the leadership of Dean Marjorie Levy who originated the idea of this exhibition and who supported and encouraged the project at every stage. My thanks go also to members of the Exhibition Committee—Kenneth Baird, Barbara Cervenka, Ted Ramsay, Takeshi Takahara—and to other colleagues on the faculty and staff of the University of Michigan School of Art, whose daily dedication to teaching and creative activity underlies and nourishes all projects undertaken in our School.

Finally, this exhibition could not have been done without Ruth Weisberg, who not only created the art, but who responded generously and tirelessly to many questions and requests for assistance throughout all stages of planning and organizing. To Ruth Weisberg and to her family, I extend our sincere appreciation.

Marion E. Jackson
Curator

It is with considerable pride that the University of Michigan School of Art welcomes home its distinguished alumna, Ruth Weisberg, B.F.A. '63, M.A. '64. Now approaching the midpoint of an illustrious career as artist, teacher, and critic, Ruth Weisberg is a recognized national leader in the visual arts. She has held to standards of achievement in her own artistic career and has nurtured the creative efforts of others with a commitment, dedication, and talent that make us very proud to have her as a part of our University of Michigan "family."

It is particularly fitting that this first major survey exhibition of Ruth Weisberg's work should open in the School of Art's gallery which is named in honor of Jean Paul Slusser, former professor, art critic, and first director of the University's Museum of Art. In a 1977 *Ann Arbor News* review of a show of Weisberg's work at the Alice Simsar Gallery, Professor Slusser called Weisberg's work "distinctly impressive" and said prophetically that in Weisberg, "we have an artist worth watching." Indeed, her creative activity during the past decade has affirmed Slusser's confidence in her as an artist and points toward her continuing productivity in the years to come.

This survey exhibition, drawn from twenty years of Ruth Weisberg's work, is the first comprehensive survey of her oeuvre. The University of Michigan School of Art is proud to present this exhibition to the University community, to Ann Arbor, and to the nation through its national tour.

Marjorie Levy
Dean

Table of Contents

Accompanied Journey

I believe that a person's work is "nothing but the long journey through life to recover, through the detours of art, the two or three great and simple images, that first gained access to his heart."

—Albert Camus

Energized by a nervous blend of excitement and uncertainty when I first unpacked my bags at The University of Michigan in the autumn of 1959, there was no way I could have known that, at the same time, just a few leaf-strewn blocks away, another freshman—Ruth Weisberg—was also unpacking her bags. She and I brought to the University different experiences, different expectations, different understandings. Ruth Weisberg was a student in the School of Art and I, a freshman in the College of Literature, Science, and the Arts. She had grown up in a Jewish home in cosmopolitan Chicago, and I was from a Christian family in a small, industrial town in Michigan. For each of us at that point, however, it seemed that our whole lives lay ahead, that we were entering into the community of a great University where we would encounter new people, where we would be challenged by ideas, and where we might grow and change in ways that we could not even imagine. It was a heady though frightening moment— and one that we were not to discuss together until we first met twenty-five years later.

Ruth Weisberg came to this experience from a wonder-filled childhood in Chicago. There, her father, Alfred—a first-generation American of Russian-Jewish heritage—had introduced her to galleries and artists' studios and had instilled in her an appreciation for the beaux-arts traditions which had influenced his own training as an architect at the Armour Institute of Technology (later, the Illinois Institute of Technology). Her mother, Theresa, was an activist for liberal social and political causes and had encouraged in her daughter a sense of social commitment and moral responsibility. Idyllic childhood summers were spent with her parents and her older sister, Naomi, in the Wilson Sand Dunes of Indiana. There the absence of electricity and plumbing simplified the Weisbergs' life and heightened their sense of communion with nature while, at the same time, involving them in a stimulating circle of Chicago-area intellectuals and artists who summered in this old, socialist community.

Both Alfred and Theresa Weisberg recognized and nurtured their daughter's early interest in the arts, and from the age of six Ruth had attended Saturday art classes at the Art Institute of Chicago. While a student at Chicago's competitive Senn High School in

the late 1950s, she continued her study of art under the guidance of a gifted teacher, Emanuel Jacobson, whose personal encouragement and whose belief in the integrity of each individual's vision influenced Ruth's decision to become an artist. In 1959, her sister, Naomi, was already studying architecture at The University of Michigan, and Naomi's presence there influenced Ruth's decision to pursue her own university education in Ann Arbor.

Though only sixteen when she entered The University of Michigan, Ruth Weisberg was already committed to becoming a serious artist. She quickly became absorbed in her class work and applied herself enthusiastically to engaging assignments from her teachers—Professors Bill Lewis, Guy Palazzola, Al Mullen, and Milt Cohen. Their emphasis was on *drawing* and *seeing* and she thrived, recalling years later that she was "blessed with really good teachers."

After her freshman year, she visited Paris and by the end of that summer had decided to pursue a beaux-arts curriculum at the Accademia di Belle Arti in Perugia where she spent the next two-and-a-half years studying painting and printmaking while boarding with an Italian family. Her favorite teacher, Padre Diego Donati, became a special influence in her life, encouraging her in her art and nourishing her exploration of Italian culture and landscape. Completing the laurea from the Accademia in half the usual time, she left Italy in 1962, returning to The University of Michigan to complete her bachelor of fine arts degree. At that time, John F. Kennedy was president, new civil rights initiatives were underway, and the atmosphere in Ann Arbor was energetic and optimistic.

Completing her undergraduate degree in 1963, Ruth entered into what was to be a short first marriage and traveled with her husband to Paris where she worked with Stanley William Hayter at Atelier 17. By the summer of 1964, the marriage had dissolved and Ruth returned again to The University of Michigan, this time to pursue the master of arts degree. Soon thereafter, she met and later married Kelyn Roberts, a doctoral student in psychology. The following five years were to be rich and challenging years for both of them, years in which they completed graduate degrees and flourished in an intellectually and socially active community. Artistically, Ruth struggled and grew—studying printmaking with Professors Emil Weddige and Frank Cassara and using her growing technical skill to explore themes of human justice and issues of social and political import.

Accompanied Journey

After completing her master of arts degree in 1965, she taught art and art history at Eastern Michigan University in Ypsilanti, while maintaining a painting studio as well as an intaglio press in the back room of the old house she and Kelyn rented at 114 Division Street in Ann Arbor. By that time, however, John F. Kennedy had been assassinated, and the youthful idealism of the early 1960s was sadly tarnished and undergoing rapid transfomation to a more radical and intense form of politics. The imagery of her art also became distorted, compressed, and painful; she searched for meaning in psychology, Jewish mysticism, and the history of ideas. Ann Arbor became an activist base for organizations and individuals championing minority rights and integration and opposing increased U.S. military intervention in Southeast Asia. Ruth and Kelyn joined with colleagues and friends in the anti-war movement as well as the performance ensemble called the Once Group, which merged avant-garde art and the causes of equality and social justice.

During these intense years, Ruth and Kelyn formed close friendships which were to have a continuing effect on their lives: friendships with artists and intellectuals, scholars and revolutionaries; friendships with such people as Al Loving and Wynn Cortes, Stuart Klein, Al and Becky Mullen, Milt Cohen, Judy (Bell) and Paul Siegel; and acquaintances with an even wider group of people, including radical Weatherman Diane Oughten, who would later die the tragic victim of an accidental explosion of homemade incendiaries in the basement of a New York brownstone (no. 4). The small intaglio print entitled *Deposition* (no. 21)—one of the earliest works in this exhibition—reflects Ruth's interests at this time. In this work, the lifeless body of the martyred Ché Guevara rests unceremoniously on a gurney, creating an uneasy diagonal in the stark morgue where a military officer points analytically and dispassionately at the mortal wound to Ché's heart. Other figures stand witness in the darkened room, and intersecting red lines bite harshly through the image, reinforcing the brutality and the oppressive sense of inevitability.

In a painting from this period, *Community* (no. 1), reminiscent of Courbet's *The Painter's Studio*, Ruth depicted herself in her studio surrounded by painted canvases and by the subjects of her painted images—her husband, Kelyn, and her Ann Arbor friends, Andrew Lugg, Alan Loceff, Al Loving, Wynn Cortes, and Jon Levine. The artistic vision implied in filling her studio with friends not physically present is formally reinforced by the layering of thin glazes, the fluidity and transparency of forms, and by the rhythm of light and dark which plays across the canvas obscuring the definition of edges. The off-balance composition and the fading of figures create a dream-like sense of flux and transformation, and Al Loceff appears not once but twice, thus defying both logic

and optical reality but simulating the experience of introspection and reverie. In this painting, Ruth demonstrates her early fascination with the interplay between the present and the past, between the seen and the unseen, and she shows her sensitivity to the congruence of complex layers of reality.

In a second painting from approximately the same time, *Summer in the Dunes* (no. 2), Ruth plumbs deeper into her memories. Here she pictures herself as she was at the time of the painting—as a young adult in T-shirt and jeans—but placed in a scene reminiscent of the Wilson Sand Dunes of Indiana, the dunes of her childhood summers. The artist stands as a witness figure, with her eyes lowered and her mood introspective. To her left, depicted in thin veils of transparent paint, are wraith-like images of herself and her sister as young children frolicking in the dunes—as they might have appeared twenty years before and as they remained in Ruth's mind. This interplay of polarities—of present and past, of knowledge and innocence, of interior and exterior realities—evident in these works produced when Ruth was in her mid-twenties has continued to the present day.

Ruth uses a bedroom mirror to explore the complex interdependence between physical and reflected reality in a painting from 1969, *In the Mirror* (no. 3). Objects on a dressing table (which include, significantly, an opened letter and other personal memorabilia) become reflections in a large bureau mirror as does the reflected image of the artist and her husband in bed. In this image from her Ann Arbor days, Ruth pictures herself and Kelyn as a young couple innocent, undefensive, and open in their vulnerability. From a round vase on the bureau top, a peacock feather curves upward and inward toward the surface of the mirror with its eye-like tip touching the mirror at the exact point where physical and reflected reality meet. The feather becomes a metaphor for the witness figure the artist so often uses to mediate between remembered or reflected reality and the present experience. Her deliberate use of feminine articles and a female point of view mark this painting as a very early feminist work.

By the end of the 1960s, friends were beginning to leave Ann Arbor, and Kelyn was offered an assistant professorship at U.C.L.A. Ruth was already gaining recognition for her skills as a teacher and artist and had held solo exhibitions in Ann Arbor's Lantern Gallery, now the Alice Simsar Gallery, and in galleries in Toronto and Seattle. Their move to California in 1969, while initially isolating for the young couple who had been so integrally a part of their Ann Arbor circle, proved ultimately nourishing for Ruth's artistic development.

Accompanied Journey

The new solitude led her to take stock of influences which had shaped her life, her thinking, and her development as an artist. Her reflections turned inward to a consideration of her own life and Jewish heritage and outward to the five hundred years of Western art history and, particularly, to the humanist artists with whom she felt most kinship—Giotto, Masaccio, Leonardo, Velásquez, Goya, Ribera, Käthe Kollwitz. The immediate past and a longing for Ann Arbor friends also filled her heart and mind at that time.

The idea of "witness" as well as a growing sense for the redemptive value of art in extracting meaning from pain, chaos, and loss increasingly became a motivation in her work. During a visit to her parents' Chicago home not long before moving to California she had pulled a book from a shelf, discovering—quite by accident—that it was a Yisker Book (remembrance book) of the village or shtetl of her deceased grandmother. One of hundreds of such personal reminiscences written during the 1950s by Jews horrified by the Holocaust, this Yisker Book inspired Ruth to confront and integrate the Holocaust experience into her own life and art. In 1970, with a Ford Foundation grant, Ruth studied books and journals at U.C.L.A. and photographs at the Institute for Yiddish Research (Y.I.V.O.) in New York in preparation for designing, writing, and creating nine etchings to illustrate the large format book, *The Shtetl, a Journey and a Memorial*, which she published in a limited edition in 1972.

A rich and mysterious etching entitled *Journey* (no. 22) from this book demonstrates Ruth's technical virtuosity as well as her complexity of thought. In this image, a solitary figure—bent but not broken—moves resolutely forward on a journey leaving the familiar home and village that had provided some refuge, comfort, and community. The isolation of this solitary figure moving alone toward an unknown destiny is heightened by the brooding sky, the starkness of the landscape, and the throbbing repetition of spike-like foreground flora which seem to push the departing figure and emphasize the irreversibility of the journey. The transparency of the figure subtly reminds the viewer that this traveler is no longer "departing" but may be, in fact, among those departed.

Researching, writing, and creating the images for *The Shtetl* proved to be a powerfully integrative experience for Ruth. She later recalled, "By the time I finished, I knew a lot more about myself as an artist, as a Jew, and as a woman."[1] Themes of journey, separation, and cultural continuity continue to underlie her work; throughout her artistic career she has made frequent references to Judaism and to the experience of the Holocaust. Particularly moved by the 1930s photographs of European Jewish children,

Ruth has remembered them and their experience in many works, among them the drawing from many years later entitled *The Game* (no. 15) showing a circle of children from a Polish shtetl, innocent and absorbed in a childhood "choosing game."

In the autumn of 1970, while still working on *The Shtetl*, Ruth began teaching printmaking at the University of Southern California where she remains today as a professor of fine arts. During the 1970s, printmaking and drawing were the primary media for her work although she continued to explore the themes of her images through other means, including writing and performance. Ruth's concern during this period for personal and collective losses extended beyond the painful losses in her own Jewish heritage to a wrenching appreciation for lost cultures, including Native American cultures to which she pays homage in the poignant 1972 lithograph, *Moon Bone Child Stone* (no. 23). Ruth articulated the meaning of this tender portrait of a Mojave child, whose head is encircled by a necklace of bones, in her poem by the same name:

The moon was closer then
Each place had a name
The bird and the spider
A wolf, a mountain
A wheel
Are all that is left
Moon bone child stone
Is gone again
Sliding safely behind
The moon
You whose death
Has already been
Forgotten[2]

Using art to "stop time" and to hold irretrievable, fleeting moments, Ruth began to invent or stage situations to examine universal human themes, incorporating both autobiographical and art historical allusions in her quest for meaning. Quoting Velásquez's *Las Meninas* in her 1975 lithograph, *Disparity among the Children* (no. 24), Ruth depicts herself not only (as Velásquez did in his own self-portrait) as the painter/observer at the easel, but also as a member of the foreground group watching with approving acceptance as her infant daughter, Alicia, runs off independently—in contrast to the confined and immobile Infanta in the Velásquez painting.

Accompanied Journey

Art historical references and theater enable Ruth to create a world of illusion and parallel vision in which to examine the human condition and probe the complicated relationship between art and life. She uses a stage proscenium and costumes and masks from the *commedia dell'arte* in a series of richly toned lithographs done in the late 1970s in which she explores relationships between appearances and reality. In one print from this series, *La Commedia è finita* (no. 27), Ruth pictures a player pulling back the stage curtain to reveal a screen of large, theatrical faces. The complexity of the image is reinforced by its title, a reference to the last line of Puccini's *Pagliacci* in which a singer announces that the play is over; what was a play has invaded reality. In another print from this series, *Fin* (no. 28), the artist again draws back the stage curtain, this time to reveal the haunting darkness of an empty stage.

These prints foreshadow one of Ruth's most important works, a nearly twenty-four-foot-long, mixed-media drawing entitled *Children of Paradise* (no. 13), inspired by Marcel Carne's wartime film, *Les Enfants du Paradis*. This massive work, completed in 1980, was the culmination of Ruth's several years' effort to come to terms with her own sense of vulnerability as an artist who, to succeed, must lay aside the security of illusionary guises and reveal the private inner being. Describing the significance of this drawing and the influence of Carne's *Les Enfants du Paradis*, Ruth later explained:

I was deeply moved by the film, the protagonist's tragic indecision, the narrative richness, but most of all the black and white images with their sense of both history and myth. I had the haunting feeling that I knew it all already—it was all familiar.

. . .I was interested in the crowd scenes, particularly the last ten minutes in which Baptiste is surrounded by a throng of carnival figures. Gradually all other costumes fade away and we see only Pierrot figures. Baptiste is drowning in his own disguise. It is the claustrophobia of a mirrored reality; like an infinite regression but one in which the other "Pierrots" circle and spin around him with a gaiety that mocks his quest. The tumultuous series of images . . .mirrored my own anxious journey[3]

For Ruth Weisberg, the decade of the 1970s was a time of challenge and growth artistically but also a time of important personal changes. Both of her children were born during this time—Alicia in 1973 and Alfred in 1977—bringing her new light and joy, and her father died, acquainting her with a new knowledge of grief. Her most personal images from this period deal with her own responses to the universal themes of birth and death and of continuity among generations. The isolation and loneliness

conveyed in the hauntingly stark, black-and-white lithograph, *Elegy* (no. 29), express not just the artist's personal response to loss but the universal human anguish in the face of death. In *Second Child* (no. 30), the palpable presence of her deceased father hovers in the empty silhouette above the image of her young daughter and infant son. Both birth and death derive meaning from an awareness of the regeneration of life and the interdependence of generations. The large totemic drawing, *1948* (no. 15), executed a few years later, carries forward this concern for connectedness, in this instance, a formalized but diaphanous image of her mother, her sister Naomi, and herself as they may have appeared in 1948 and as they had lived in Ruth's memory for more than three decades.

The birth of her own children and death of a parent heightened Ruth's awareness of the passing of years in her own life. In her late thirties, she executed a series of drawings, prints, and paintings entitled *Phantoms and Lovers* (nos. 5, 14, 32) in which she explored themes of personal identity and the guises with which one lives at different periods in life. Powerful issues of sexuality, seduction, impotence, and nurturance are dealt with in these enigmatic, theatrical works with dramatically posturing figures presented in the artificial color and exaggerated chiaroscuro of stage lighting. Indicating that, in these works, she intends to confront and ask the viewer to confront the "passionate attachments, spiritual quests, and irrevocable losses in the lives of men and women," Ruth explains the *Phantoms and Lovers* series thus:

Here, the viewer is the audience, the stage the mirror, and the artist a dreamer of vivid dreams. The cast of characters act out scenarios of adult life which are familiar to all of us, but which I have left intentionally ambiguous and open-ended. The inward turning older woman, the emotionally crippled young man, the erotic and aloof beauty—each have their own history. They are all players on the stage and at the same time are all aspects of the self. [4]

In working through the philosophical and psychological issues in *Phantoms and Lovers* and in finding means to give form to her complex ideas, Ruth utilized all three of her favored media—drawing, printmaking, and, after a hiatus of approximately eight years, painting.

In the mid 1980s, she turned to a major cycle of paintings which she envisioned as a summary statement of her personal beliefs and the major themes of her art. The result, *A Circle of Life* (nos. 6, 7, 8), is an integrated series of eleven large-scale paintings on

unstretched canvas using autobiographical, historical, and mythic sources to explore themes of birth and death and the continuity of generations and cultures. This important series of paintings and the recently completed ninety-four-foot work, *The Scroll*, are discussed in this catalogue in the essay by Thalia Gouma-Peterson.

During the two years that Ruth worked on *The Scroll*, she made a number of drawings and prints inspired by Jewish writings. A particularly poignant passage in an early phase of the *The Scroll* depicts the Creation as the birth of a child. The 1987 lithograph, *Awakening II* (no. 33), drawn from Jewish folklore, deals with this same theme. The image is of an angel pressing upon the upper lip of of an unborn child to impart mortal life and to erase from memory the perfect knowledge that precedes birth. It is said that all mortals carry an indentation just above the upper lip as evidence of the angel's push at the moment of birth.

The most recent works in this exhibition and those that most likely point to Ruth Weisberg's future artistic directions are the 1987 drawing, *The Other* (no. 19), and the 1988 painting, *Wrestling with the Messenger* (no. 10). Both of these works draw their inspiration from the passage in Genesis 32:22-32 in which Jacob wrestles through the night with the unnamed Messenger. Through the ordeal, Jacob's Divine Adversary gives him the strength he needs to continue wrestling so that he is not overcome and destroyed. By the end of the night, Jacob is able to identify "the Other" with whom he has wrestled and from whom he has received both a blessing and a wound, and he knows that he has encountered God face to face and survived. In these latest works, Ruth lifts personal and cultural struggles from temporal limitations, elevating these trials to a spiritual level in her quest for a vision of life's wholeness. Though she uses her own self-portrait in *The Other*—just as she has used self-portraits and the likenesses of loved ones in many of her works—this image, like the others, rises above the level of personal anecdote. This is not Ruth Weisberg's trial with a Messenger nor is it Jacob's. Rather, it is everyone's trial. Portrayed in this small wash drawing is the universal human effort to find meaning, to endure suffering, and to find wholeness.

In Ruth Weisberg's concern with the universals in the human experience, her art transcends the bounds of one woman's quest for redemption and her works rise above the realm of the personal. Her own journey through life and mine have continued to move down different paths in the years that followed that autumn day in 1959 when, unknown to one another, we simultaneously unpacked our bags as University of Michigan freshmen. Her images, however, recall sorrows that I, too, have felt, though differently,

16

and touch on quests in which I, too, have engaged, albeit in different ways. At some level, however, her images suggest that she has accompanied me on my journey, or I on hers—a reminder to each of us and to all who engage in the viewing of these works of our shared humanity, a comforting affirmation of connectedness in a fractured world.

Works of art become symbolic realities capable of changing each time they are apprehended. To find meaning in a work of art, it is not necessary that a viewer share with the artist the same experiences, same expectations, same understandings. When a work of art is complex, and deals, as Ruth Weisberg's does, with the universal themes of human experience, the viewer participates in discovering and imparting meaning by bringing to the work the specifics of his or her own experience.

Concerned with the redemptive value of art, Ruth seeks the wholeness that encompasses both the pains and joys of living—and of dying. In her work, we are constantly reminded that dying is part of living, looking back is part of looking ahead, yesterday is part of today, dark is part of light, passing is part of permanence, exit is part of entrance, and the finite is part of the infinite. Ruth's struggle is the human struggle in which we all engage. One of the noblest roles of the arts is to impart to all who understand them a grace for dealing with this struggle.

Marion E. Jackson
The University of Michigan School of Art
Ann Arbor, Michigan

Notes

1 Ruth Weisberg, personal communication to author, 1987.

2 Ruth Weisberg, "Moon Bone Child Stone," published in Gilah Yelin Hirsch, "Ruth Weisberg: Transcendence of Time Through Persistence of Imagery," *Woman's Art Journal*, (Fall 1985/Winter 1986): 41-45.

3 Ruth Weisberg, in letter to Gordon Gilkey, Portland Art Museum, 1984.

4 Ruth Weisberg, excerpt from personal journal, 1983.

Passage:
The act or an instance of passing from one place, condition, etc., to another.
The permission, right, or freedom to pass.
The route or course by which a person or thing passes or travels.
An opening or entrance into, through, or out of something.
A voyage by water.
A lapse or passing, as of time.
A progress or course, as of event.
An interchange of communications, confidences, etc., between persons. [1]

During the last five years, in what can be considered her most significant body of work so far, Ruth Weisberg has told a story of passage. In *A Circle of Life* (1984-85), a series of eleven large paintings in diaphanous layers of oil on unstretched pieces of cloth, she tells of personal passages past, present, and future. [2] In *The Scroll*, (1986-87), a ninety-four-foot-long ink and wash drawing on paper which envelops a whole gallery space, she overlays passages in her own life and the lives of family and friends with passages in Jewish and Biblical history. [3] In both the *Circle* series and *The Scroll*, she gives herself permission (the right, the freedom) to pass through silence: the silence of over three thousand years of official Judaic tradition, which has not permitted women to speak with the authority of the Biblical text, and the silence of Western culture, which has denied the authority of woman's narrative voice. In claiming the right to tell her story as a contemporary American Jewish woman, Weisberg is reclaiming her authority as the perceiving subject. In asserting her belief in the value of her own individual experience, she challenges male-dominant ideology, which has consistently encoded woman as object in both text and image. As she develops possibilities for the interpretation of her own life and that of other women, she affirms her femaleness and claims autonomy. [4]

This body of work is an act of passage. In her use of both form and content, technique and iconography, Weisberg is one of those contemporary artists who are reshaping the pictorial language of the male-dominant culture. In doing this, she is addressing two questions identified as central by feminist artists and critics: first, "How is it possible to make texts through which women's points of view can be articulated?" and second, how can woman "be positioned as the subject not the object of both vision and discourse?" [5] In both the paintings and the scroll, Weisberg deconstructs meanings by employing familiar media and modes which audiences find easily negotiable. [6] She uses a figurative style that refers, in a general way, to past academic tradition and intentionally avoids

current post-modern styles of expressionist overemphasis, strident color, pictorial fragmentation, or precise neoclassicism. In *A Circle of Life,* she applies the oil in layers, primarily of ultramarines and burnt siennas, to enhance the tapestry-like quality of the paintings. In *The Scroll,* she tempers the contrast between the white paper and black ink with modulated black washes and passages of light blue-greens, purples, yellows, and reds which create extraordinary effects of luminosity. The prototypes that come to mind are Japanese landscape scrolls and the Byzantine *Joshua Rotulus* in the Vatican Library. But unlike the former, *The Scroll* is a figurative narrative and unlike the latter, it is a story of peaceful passage rather than of war and destruction. In both the paintings and the scroll, autobiography is tempered by classicizing generalization and the specific is made timeless. The dialectic between the patriarchal tradition of the past and woman's unofficial voice is carried further through Weisberg's use of autobiography and folklore as sources of equal importance with official history. It is in this body of work that her public and private persona completely merge for the first time in her oeuvre.[7]

Time and memory have been central to Ruth Weisberg's art. The impulse to hold on to friends, ancestors, and the shared past has been at the core of her creative thinking. The memory of those who perished in the Holocaust has possessed her since her early twenties. She sees herself as "a branch, a resting place for their souls."[8] Thus, *A Circle of Life,* her autobiographical recasting of the Renaissance concept of The Ages of Man and of Munch's *Frieze of Life,* begins not with a scene of birth but with *The Past: The Great Synagogue of Danzig.* A group of Jewish children (derived from an early-twentieth-century photograph) holding hands in a circle, stand in front of a wooden gate layered over a vision of the Great Synagogue, the most important sanctuary of Jews of Poland. They are a memory, the souls of those who died.

This diaphanous vision of the dead, seen "through a veil of time and memory," is followed by a striking image of birth in *Waterborne* (no. 6). A large nude woman (a self-portrait) crouched in a fetal position, which can also be seen as a position of birthgiving, is afloat in the amniotic fluid of the womb. Through this image, which is both giving birth and being born, Weisberg stresses the concept of continuity in time, which is central to the cycle, and is restated in the next painting, *The Dunes: The Persistence of Memory* (no. 7). Here, childhood is shown as the artist's memory of herself, her sister, and friends in the Indiana sand dunes, where she spent many happy summers as a child. The mature artist in the distant background is remembering herself as a young girl in the context of a group of friends, and in a second image in the right foreground, as ready to move on her life's journey by herself. The motif of exits (passages)

from the right foreground into the next stage of life, is a thematic bond that runs through the next six paintings.

The swift voyage through childhood is movingly and poetically captured in *The Accompanied Journey*. The young girl runs along a curving, snow-covered train track, followed by her own dark shadow and observed by a stationary young boy. The children again are diaphanous visions, seen against the backdrop of the houses along the Chicago El tracks. The knowledge that the children are the artist's own and that Chicago is the city where she grew up, reaffirms the autobiographical nature of the cycle. However, this knowledge is not essential to an understanding of the central meaning of this passage through childhood and its relation to the rest of the cycle. In the next stage of the journey, having reached her late teens, the young woman has become a glowing, golden vision in the vast hall of a museum (*Museum*), where she is flanked by symbols of male power: Verrocchio's fierce *Colleoni* and the imposing gate of an Italian princely palace. The double image of the young woman (again self-potraits) in bathing suit and sneakers is aimlessly treading on the same spot, caught in the charmed beauty of her own glow. On the right, however, a shadowy female figure in grisaille, perhaps an allusion to the Muse, is about to pass through the dark palace gate.

The quest for the Muse, that is, woman's creative power, is the subject of the sixth, central, and largest painting in the cycle (120 x 71 inches). Entitled *Pentimento* (no. 8), it represents a panoramic view of the central Italian landscape which the artist resolutely enters. Seen from the back, barefoot and in a light-blue dress, her image almost merges with the landscape. She is on a pilgrimage, back in the land where she studied as a young woman, and in the country whose great masters have formed her artistic heritage. However, she is not looking at them, but instead looks at the land, unaware that in the right foreground the weeping figures of Masaccio's *Expulsion* walk out of the painting. The contrast between the resolutely striding artist and the wailing Eve, shamefully covering her body, is eloquent. At the center of this complex painting are the painful and contradictory realities of woman's definition. As the artist turns her back on the image of woman as "the original cause of all evil" (Bernard of Clairvaux), she looks at her own dark blue shadow that looms large on the land and within which appears her nude body, painted in a saturated red which bleeds into the earth below. As she turns away from her culturally codified image, the artist still has to confront the reality of her body. This passage away from encoded image towards existential reality is the most difficult for woman to make. The complexity of contradictory feelings is also suggested by the title, *Pentimento*, which means a change or alteration in the composition of an image,

a painting over, a covering of what was there before.

Pentimento is followed by two paintings very different in nature, one of growing independence (*Circle and Leave*) and one of anguished pain (*A Year Passes*). They deal with the joys and sorrows of growth and self-realization. Both are set in open landscapes, in sand dunes and along the sea, and both are divided into two parts by a subtle change in the color scheme. *Circle and Leave* presents passage as a course of changing relationships between a young woman and a series of men with whom she dances in a semicircular formation. At the end the woman, in her new-found autonomy, leaves by herself along the sandy seashore on the right. *A Year Passes* deals with the passage of time and its painful consequences. The title specifies the time as one year and the double self-portrait suggests that Weisberg is alluding to a particular year in her own life, a year of pain and profound insight. However, the painting goes beyond the specifics of autobiography to deal with woman's painful passage into maturity. Its compositional scheme and iconography are related to an earlier painting in the cycle, *The Dunes: The Persistence of Memory*. The similarities emphasize the profound difference between these two paintings. In both, the artist represents herself in the background, clad in a bathing suit and resolutely striding forward, with arms firmly placed on her hips. In *Dunes* she looks toward her happy childhood memories. In *A Year Passes* she looks at her own repeated image, which has become tragically older and anguished. But this woman, now middle-aged, continues to stride resolutely forward and outward to the right.

The next painting, *Circle*, concludes the sequence of autobiographical passages and firmly establishes the authority of the artist's narrative voice. In the lower right, the artist at her worktable is creating the images of her own story: a circle of friends and relatives happily engaged in the dance of life. One of the figures is literally in the process of being created, as she rises from the artist's table. Weisberg reiterates the focus on woman's power of creation through a second self-portrait, actively dancing in the circle. The leg of the dancing image touches the back of the working artist and the whole figure appears to be physically emerging out of the other. This is again a scene of birth—birth from the creative mind. But Weisberg is careful to also emphasize the physical connection between the two images. Mind and body, which in the case of woman have so often been separated, here coexist. By leaving a substantial part of the body exposed, Weisberg stresses the physicality of both her creative and her dancing self.

The two last scenes in the cycle, *Passage* and *The World to Come*, deal with the end of the voyage, the passage into death. They are darker in tonality and depend primarily on

contrasts between white and dark tones of burnt sienna, burnt umber, and ultramarine. They are solemn but not morbid or pessimistic. Weisberg's image of death remains closely bound to life. In *Passage* a young woman, draped only in a short white cloth, strides resolutely to the right. Pensive, serious, and innocent, she could be seen as an allegory of the human soul. She is surrounded by shadowy presences of figures dressed in late-nineteenth-century clothes, her ancestors whom she is about to join. The same shadowy figures, seen through a "veil of memory," populate the last painting in the cycle, *The World to Come*. They hover around a large wooden door which could also be a ladder and which is reminiscent of the wooden gate in front of the Great Synagogue at Danzig. As it began, the circle of life closes with the memory of those who died. This multitude of souls looks much like the immigrants crowded together on the ships that began arriving in the New World around 1870. Weisberg sees the final passage as a voyage by water, a lapse of time, a passing from one condition to another. As in Jewish religious thought, she conceives of the souls as merging again with the living and continuing their cyclical journey.

In *A Circle of Life*, Ruth Weisberg has created both a new plot and a new imagery for the story of woman's life. She has freed woman from the outworn plots of male-dominant ideology and has given her permission to tell her own story. Central in this is Weisberg's reclaiming of her body as a participant in her capacity to paint.[9] The nude or only scantily dressed female body is a central motif throughout the cycle as in the powerful image of birth-giving (*Waterborne*), as the energetic vision of the teenager (*Museum*), as the active image of the narrator observing her own life (*The Dunes, A Year Passes*), as the creative artist in search of her identity (*Pentimento*), as begetting her own image (*Circle*), and as the human soul (*Passage*). The energy and vitality of the female body in all these images questions the encoded image of woman's body as passive, erotic, seductive, and as available for the delectation of the male gaze.[10] Furthermore, throughout the cycle woman's body is an extension of an equally active mind. In each painting, the female protagonists are either actively involved or look outward and engage the spectator in a direct encounter, and frequently the protagonist is the artist herself. These pictorial devices create for woman a different kind of presence. They realize the liberating possibility "of direct access to audience and assertion of immediate, personal agency."[11]

The search for self-definition is, however, difficult. The claim of personal agency cannot easily be achieved by a woman. This is the central theme in the contrast between *Museum* and *Pentimento*. In *Museum*, the young woman, entrapped in the glow of her own beauty, is in danger of being enshrined as an object and, therefore, losing her own

reality. She has been reduced to the status of a reflection, the "Other," to which the mythology of male-dominant culture reduces woman. [12] In her quest for personal agency, woman has to confront this tradition within which she is inscribed and which is preserved in and represented by the museum. That is the cultural heritage on which all Western artists have been raised, that they have admired, and from which they have drawn their role models. Therefore, the artist's pilgrimage to Italy is doubly significant as a journey of self-discovery. In dealing with her memories of the past she is reaching a new reality. In *Pentimento*, Weisberg claims her own reality of body and mind and in the process turns her back on much that she has admired. In doing so, she rejects the sense of otherness represented by the image of Eve in Masaccio's fresco. This is also expressed in the cycle as a whole, for Weisberg, who in much of her previous art had set herself within the context of past tradition through specific references to Velásquez, Watteau, and others, in *A Circle of Life* acknowledges culture only as a memory, from which the artist breaks away in order to act in an environment free of cultural texts.

Nature as a setting is important throughout the cycle. Five of the eight autobiographical paintings are set in a landscape and *Waterborne* within the natural ambient of water. The other two, *The Accompanied Journey* and *Museum*, passages in which the identity of the growing girl is in flux, include manmade structures which suggest barriers, the potential threat culture can pose for women. Significantly, in both paintings the young girl is framed by elements of nature: the snow-covered trees along the Chicago El tracks and, in *Museum*, a segment of woods and marshy land. In both paintings, these segments of nature act as a screen or protective force around the girl. The opposition between culture and nature and woman's conflict in relating to them is most clearly stated in *Pentimento*. As the artist turns her back on the cultural past, she moves into a panoramic landscape, which in its sweeping breadth contrasts with the pitiful remains of Masaccio's fresco. The only painting in the cycle in which culture alone forms the setting, *The Great Synagogue of Danzig*, is associated with the past and the memories of those who died. Nature, on the contrary, is the arena where the mature woman acts out her life.

Telling her story in eleven monumental, tapestry-like paintings (which range in size from 64 x 59 inches to 120 x 71 inches) was a major passage for Ruth Weisberg. It gave her freedom to claim narrative authority not only for her own life, but also for those of others and to tell the story of her people. In *The Scroll*, she invented a continuous narrative for a story that had never before been told in images. She transformed an ancient type, the rotulus, the repository of sacrosanct knowledge from which woman has been regularly excluded, by giving it monumental dimensions. She invented a new

imagery for Jewish art which has been predominantly non-iconic. She told Jewish history which has never been told by a female voice, and she made this story her own by interweaving events from her life with the Biblical past and more recent history.

In using a type and tradition of great antiquity and placing it in a twentieth-century context, she appropriated the shared past and transformed it. But, unlike the use of appropriation in much contemporary art, Weisberg's is a positive appropriation, one that reads forward from the past into the present. [13] Before beginning *The Scroll*, she devoted a year to the study of Judaic religious tradition and custom, a study that she is continuing. This is evident in the thematic conception and tone of the work. However, with *The Scroll* Weisberg is also exploring the boundaries of Judaic tradition, deconstructing its center and transposing its visual codes. [14]

Weisberg has been fascinated by the dramatic, narrative, and filmic possibilities of the scroll format since the mid-seventies. While working on *A Circle of Life*, she began to conceive of a more focused cycle of images which would move from birth to death, using mythic, historical, and autobiographical sources. In this cycle, as in the previous one, she wished to suggest continuities, transformations, and the impermanence of human life and culture, but she wished also to represent the life journey of the individual within a historical and cultural matrix. In *The Scroll*, she combined autobiography, history, folklore, and theology to create the text of her life in the context of Judaic tradition. She focused on three abstract theological concepts—Creation, Revelation, and Redemption—transformed them into tangible images and fused them with Biblical events such as the Parting of the Red Sea and the Giving of the Torah at Mt. Sinai. Within these, she interwove events from her own life as examples of shared cultural experiences. Central to the bonding of these diverse layers is the Jewish concept of "synchronic time," the continuity and interpenetration of time, suggested both by the scroll format and the layering of images.

In accordance with Jewish custom, the narrative of *The Scroll* reads from right to left. It consists of five parts—*Creation, Tallit, Revelation, Torah,* and *Redemption*—and it both opens and closes with the multitude of souls which, as in *A Circle of Life*, are dressed in late-nineteenth-century clothes, ready for the great voyage. Their presence at the opening and closing of the scroll establishes a sense of circularity and recurrence in time. This is in keeping with the Jewish belief that only 600,000 souls existed at Revelation and therefore, because of their finite number, they now have to be shared. The multitude of souls present at the beginning and the end of the cycle suggest both their imperishability

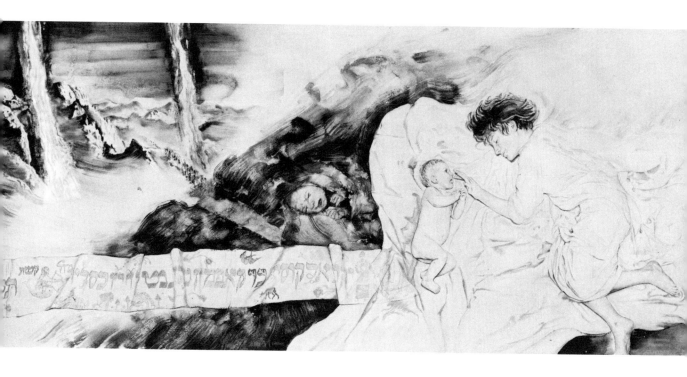

Fig. 1. *The Scroll*, 1987, detail

and our potential access to them. The tangibility of Weisberg's conception of the souls as ancestral figures of the not too distant past, is carried through in the rest of the narrative.

In *Creation*, she conceives of the first passage in the cycle as a poetic scene of birth. The soul, represented as a baby in the womb, is approached by a messenger from heaven, a wingless angel who pushes it out by touching it beneath the nose. This gentle touch sets the birthing process in motion and we next see the soul, now a human baby, emerging from the birth canal. Weisberg's source for this most human and female visualization of creation is Jewish folklore, which also specifies that the soul was so comfortable and content in the womb, in its perfect knowledge of the Torah (the entire body of Jewish law), that it did not want to be born. With the passage from the womb into the world, the narrative moves from the intimate ambient of the first scene to the agitated waters of the Red Sea, into which the water of the birthing canal merges. This expansive seascape, with its columns of fire and smoke, alludes to the Biblical Exodus from Egypt and the Passover festival. The tumultuous waves are in turn transformed into the desert peaks of Mount Sinai, which form the background for the concluding passage of *Creation*, the circumcision of the male child.

The three parts of this first section are bound together by the image of a Torah wimple, a long strip of embroidered cloth, that runs along the lower border of the composition. This image is a leitmotif throughout the scroll and, as in life, connects the main passages in the human journey. Torah wimples, embroidered with images and words of good wishes, have been and sometimes are still used to swaddle the infant at birth, to wrap the Torah scroll at the bar mitzvah or bat mitzvah, and are occasionally placed with a person in burial. The major blessing for the child on this embroidered swaddling cloth, is for "a life of Torah, wedding and righteous deeds."[15]

In spite of the hope it offers for Revelation and Redemption, *The Scroll* is rooted in this world. Its hope is based on the validation of human lives through knowledge and the spiritual insight it gives. This knowledge Ruth Weisberg is claiming for women. The presence of women is manifold throughout the scroll: in the repeated portraits of Rabbi Laura Geller, in portraits of the artist's mother, sister, daughter, and friends, and in her self-portraits; in the visualization of *Creation* and *Redemption* as specifically linked to women; in the prominent place of women in *Revelation*, in the continuous presence of the Torah wimple, woven and decorated by women. All these images bridge the distance between the traditional concept of woman in the past, created by patriarchal culture, and the modern woman rabbi. They also assert that, within their circumscribed roles in

the past, women have contributed significantly to the cultural matrix. Again, as in *A Circle of Life*, woman is present as both body (the giver of life) and mind (the teacher and student of Torah) and as an active agent throughout cyclical time.

At a time when feminist critics and theorists have asked "Can women interpret their own experience or is experience itself always already interpreted?"[16] Weisberg is affirming woman's authority to reinterpret. She has created her visual narrative in order to make sense of experience and to claim a shared reality with other people.[17] With her feminist visual texts, she has addressed both specifically female concerns and critiqued patriarchal institutions. Recognizing that woman has been a fixed category determined through societal and cultural institutions, she has questioned the culture in which these definitions of femininity have been produced. She has also provided alternatives by identifying woman as the creative subject and by representing her in a cyclical process of becoming. In doing this she has shown that it is possible to make texts that articulate a woman's point of view and that unfix the feminine.[18] In her work she, the artist/author, becomes both subject and object. Using herself as the changing object of her own narrative, she has created a multiple perspective in time and space that shows woman as creator of her own reality and as maker of history. In *The Scroll*, the Torah wimple in its passage through time is a sub-text, the commentary of the colonized on official history. But, being the only written text in the whole work, this female commentary assumes a major role as narrative voice. For this female voice Ruth Weisberg claims equal authority, not as a fixed entity but like the wimple, in changing patterns, configurations, and colors.

Thalia Gouma-Peterson
The College of Wooster
Wooster, Ohio

Notes

1 Random House Dictionary of the English Language.

2 Unless otherwise stated, all comments by Ruth Weisberg derive from correspondence and discussions carried out in the spring and fall of 1987. For *A Circle of Life*, see Selma Holo, *A Circle of Life, Ruth Weisberg* (Los Angeles: Fisher Gallery, University of Southern California, 1986): 9-15.

3 Nancy Berman, "Tradition and Self: an Artist's Vision," *Ruth Weisberg The Scroll* (New York: Hebrew Union College-Jewish Institute of Religion, 1987), and Thalia Gouma-Peterson, "Passages in Cyclical Time: Ruth Weisberg's *Scroll*," *Arts Magazine*, (February 1988): 56-60.

4 For an excellent discussion of this concept in the work of women novelists see Joanne S. Frye, *Living Stories Telling Lives: Women and the Novel in Contemporary Experience* (Ann Arbor, 1986), 6. Weisberg's recent autobiographical narrative work has much in common with women's literary narrative. Therefore, Frye's study of women and the novel is germaine for an analysis of Weisberg's art.

5 See Rozsika Parker and Griselda Pollock, *Framing Feminism: Art and the Women's Movement, 1970-1985* (London: Pandora Press and New York: Routledge and Kegan Paul, 1987), 72-74.

6 *Ibid.*, 57.

7 In 1973-75, at the time of the birth of her daughter, Weisberg dealt with themes of pregnancy, childbirth, and infancy in her art. In 1976, she began using the theater and ballet as subjects. These, as she has stated, refer to her public versus private persona. She continued to create some overtly autobiographical works during these years, but they remained separate from the theater and ballet pieces. For examples of works from this period see *Ruth Weisberg Survey Exhibition, 1971-1979* (Los Angeles: Los Angeles Municipal Art Gallery, 1979).

8 Ruth Weisberg, *The Shtetl, a Journey and a Memorial* (Santa Monica: Kelyn Press, 1971).

9 Frye, 4-5.

10 Woman's presence in art as the embodiment of male fears and desires was first discussed by John Berger, *Ways of Seeing* (New York: Viking Press, 1973), 54-64. It was also addressed in Laura Mulvey's important early article "You Don't Know What is Happening, Do You Mr. Jones?," *Spare Rib* 8 (1973): 13-16, 30, republished in Parker and Pollock, 127-131. For further discussion of this issue see Thalia Gouma-Peterson and Patricia Mathews, "The Feminist Critique of Art History," *The Art Bulletin* LXIX, no. 3 (September 1987): 338-340.

11 Parker and Pollock, 261-262.

12 *Ibid.*, 140. This is discussed by Rosetta Brooks in "Woman Visible: Women Invisible," *Studio International* 193 (1977): 208-12, reprinted in Parker and Pollock, 139-43.

13 A similar approach to past tradition has been taken by theologian Margaret Miles in *Image as Insight: Visual Understanding in Western Christianity and Secular Culture* (Boston: Beacon Press, 1985).

14 Parker and Pollock, 53.

15 For a complete discussion of *The Scroll*, see Berman and Gouma-Peterson. The Torah wimple represented by Weisberg is an eighteenth-century example in the collection of the Skirball Museum in Los Angeles, the same museum which owns *The Scroll*. Therefore, after March 1987 and its permanent installation in the Skirball Museum, viewers will be able to see *The Scroll* and this Torah wimple side by side, a fitting commentary on continuity in time.

16 Frye, 15.

17 *Ibid.*, 18.

18 Lisa Tickner, "Sexuality and/in Representation: Five British Artists," *Difference: on Representation and Sexuality* (New York: The New Museum of Contemporary Art, 1984), 28. The work of the artists whom Tickner discusses has little in common, either formally or conceptually, with Weisberg's art. However, Weisberg, like these British artists, is aware that "relations and events do not 'speak themselves' but are *enabled to mean* through systems of signs organized into discourses on the world" (Tickner, 19). Like them, with her art, she wishes to undo the feminine as a "'marked term' which ensures the category of the masculine as something central and secure" (Tickner, 18). In both *A Circle of Life* and *The Scroll*, the feminine is shown as unfixed and central, and the masculine has completely lost its centrality.

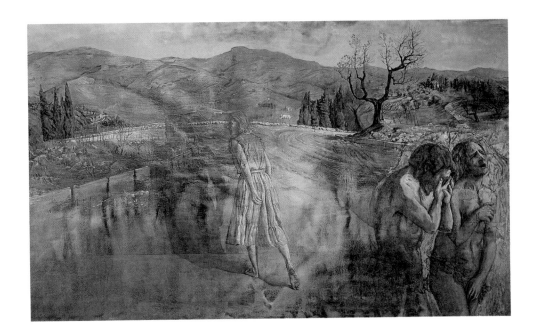

8 *Pentimento*, 1985

Oil on unstretched canvas
180.3 x 306.0 (71 x 120 1/2)
Collection Naomi Weisberg Gottlieb
Ann Arbor, Michigan

4 *In Memory of Diana*, 1971

Oil on stretched canvas
Triptych, 89.8 x 204.1 (35 3/8 x 80 3/8)
Collection Jon Levine
San Francisco, California

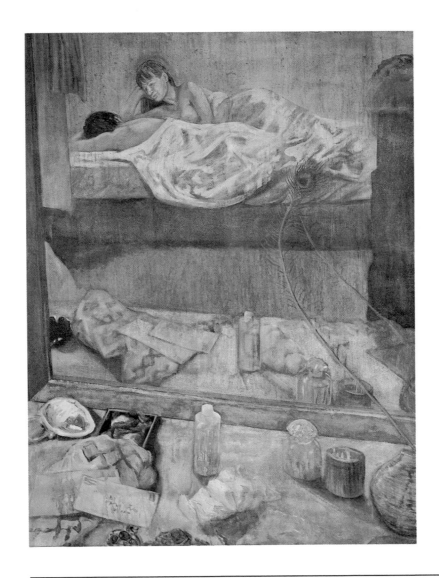

3 *In the Mirror*, 1969

Oil on stretched canvas
165.1 x 133.6 (65 x 52 1/2)
Courtesy Alice Simsar Gallery
Ann Arbor, Michigan

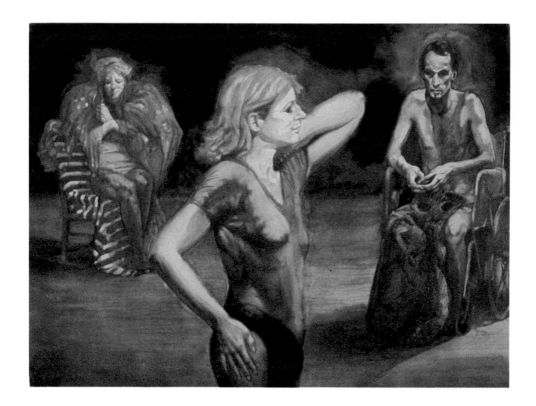

14 *Regrets*, 1981

Mixed media on paper
79.4 x 104.1 (31¼ x 41)
Courtesy Jack Rutberg Fine Arts
Los Angeles, California

12 *Portrait of the Artist*, 1980

Mixed media on paper
73.7 x 70.7 (29 x 27 7/8)
Collection Ruth Nash
Larkspur, California

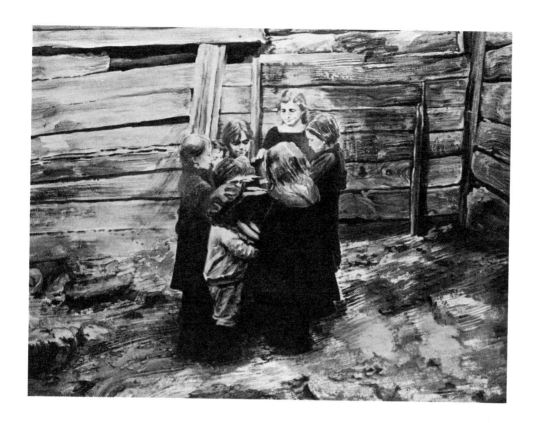

16 *The Game*, 1984

Mixed media on paper
88.9 x 120.7 (35 x 47 1/2)
Collection David and Janet Schein
Los Angeles, California

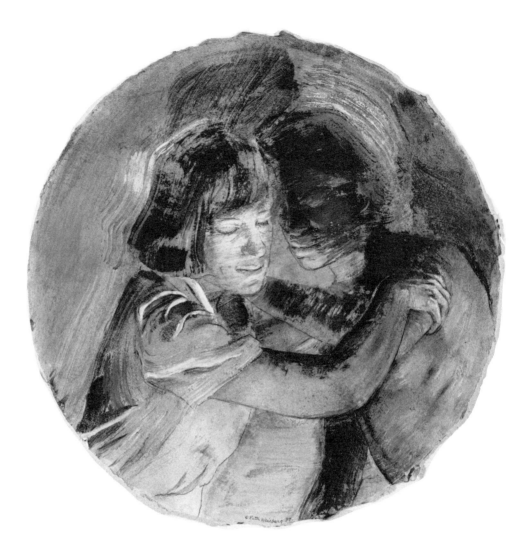

19 *The Other*, 1987

Mixed media on paper
Tondo, 56.5 (22 1/4) diameter
Collection Josephine Withers
Washington, D.C.

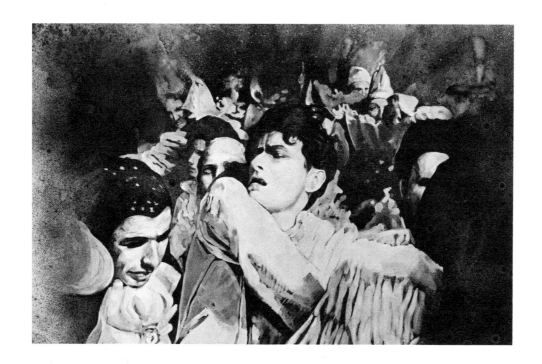

13 *Children of Paradise*, 1980, detail

Mixed media on paper
112.3 x 722.6 (44 x 284 1/2)
Portland Art Museum
Sandy and Adrea Bettelman Fund
Portland, Oregon

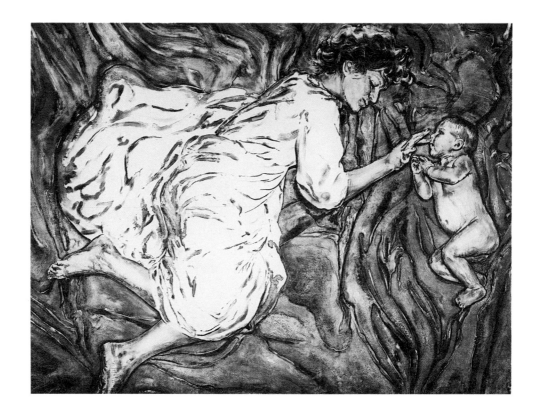

33 *Awakening II*, 1986

Four-color lithograph 6/22
75.2 x 102.2 (29 5/8 x 40 1/4)
Collection Barbara Bach Eldersveld
In memory of Peter H. Damon
Ann Arbor, Michigan

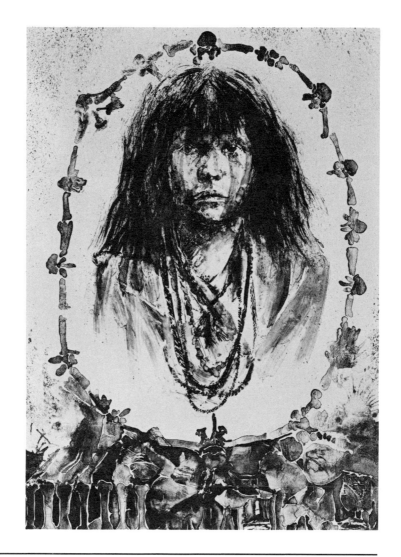

23 *Moon Bone Child Stone*, 1972

Two-color lithograph 2/40
106.7 x 75.8 (42 x 29 7/8)
Collection Karl and Gloria Frankena
Ann Arbor, Michigan

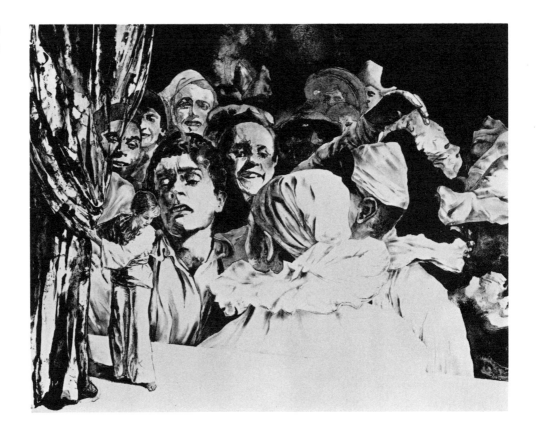

Prints

27 *La Commedia è finita*, 1977

Black-and-white lithograph 2/30
75.2 x 94.9 (29 5/8 x 37 3/8)
Collection Robert and Janice Richter
San Francisco, California

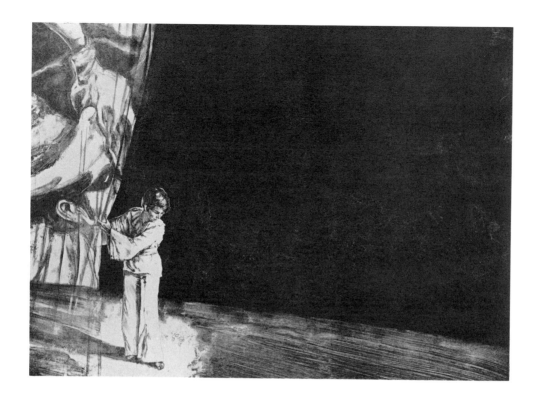

28 *Fin*, 1977

Black-and-white lithograph,
Artist's Proof, State I
75.2 x 105.1 (29 5/8 x 41 3/8)
Collection Janice and Robert Richter
San Francisco, California

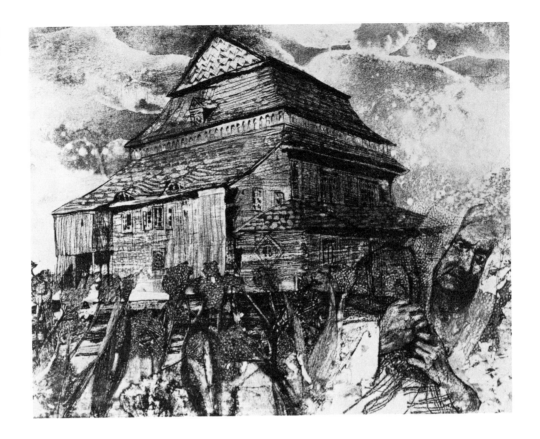

22 *Journey*, 1979

From the book *The Shtetl, a Journey and a Memorial*
Black-and-white intaglio 18/40
30.1 x 39.4 (11 7/8 x 15 1/2)
Collection Myron and Bobbie Levine
Ann Arbor, Michigan

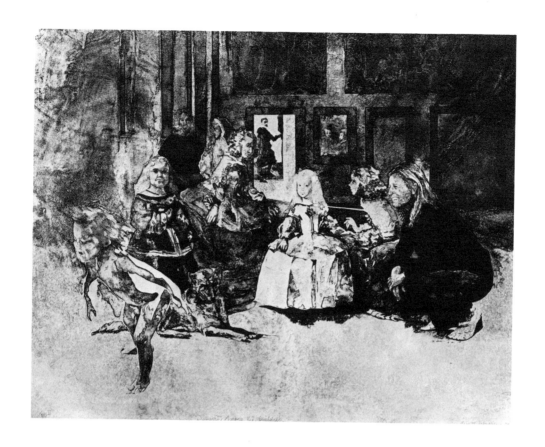

24 *Disparity Among the Children*, 1975

Four-color lithograph 17/25, State II
75.2 x 96.5 (29 7/8 x 38)
The Art Institute of Chicago
Gift of Mr. and Mrs. Harold R. Flesch
1976.106
Chicago, Illinois

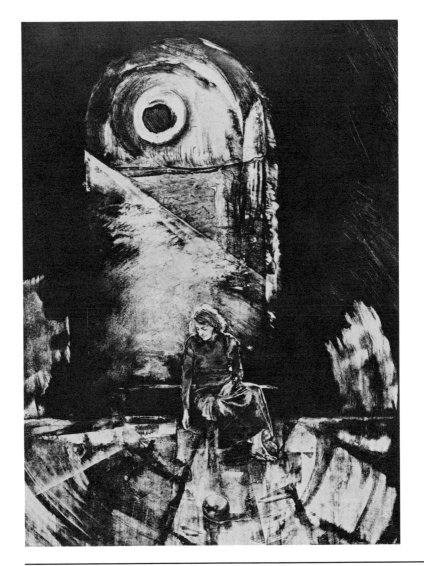

29 *Elegy*, 1977

Black-and-white lithograph 18/36
102.3 x 75.2 (40 1/4 x 29 5/8)
Collection Theresa Weisberg
Los Angeles, California

Paintings

1 *Community*, 1968
Oil on stretched canvas
177.8 x 213.4 (70 x84)
Courtesy Alice Simsar Gallery
Ann Arbor, Michigan

2 *Summer in the Dunes*, 1968
Oil on stretched canvas
152.4 x 177.8 (60 x 70)
Collection Naomi Weisberg Gottlieb
Ann Arbor, Michigan

3 *In the Mirror*, 1969
Oil on stretched canvas
165.1 x 133.6 (65 x 52 1/2)
Courtesy Alice Simsar Gallery
Ann Arbor, Michigan

4 *In Memory of Diana*, 1971
Oil on stretched canvas
Triptych, 89.8 x 204.1 (35 3/8 x 80 3/8)
Collection Jon Levine
San Francisco, California

5 *Aura of Becoming*, 1982
Oil on unstretched canvas
165.1 x 337.8 (65 x 133)
Courtesy Jack Rutberg Fine Arts
Los Angeles, California

6 *Waterborne*, 1984
Oil on unstretched canvas
149.9 x 162.6 (59 x 64)
Courtesy Jack Rutberg Fine Arts
Los Angeles, California

7 *The Dunes: Persistence of Memory*, 1984
Oil on unstretched canvas
182.9 x 266.7 (72 x 105)
Collection Gary and Brenda Ruttenberg
Los Angeles, California

8 *Pentimento*, 1985
Oil on unstretched canvas
180.3 x 306.0 (71 x 120 1/2)
Collection Naomi Weisberg Gottlieb
Ann Arbor, Michigan

9 *Small Liberties*, 1986
Oil on wood panels
Diptych, 30.5 x 58.4 (12 x 23)
Collection Sandy and Adrea Bettelman
Beverly Hills, California

10 *Wrestling with the Messenger*, 1988
Oil on unstretched canvas
168.3 x 151.1 (66 1/4 x 59 1/2)
Collection of the artist

Drawings

11 *Winter Dancers*, 1979
Mixed media on paper
74.9 x 104.1 (29½ x 41)
Collection Lisa Welborn Russell
Canoga Park, California

12 *Portrait of the Artist*, 1980
Mixed media on paper
73.7 x 70.7 (29 x 27 7/8)
Collection Ruth Nash
Larkspur, California

13 *Children of Paradise,* 1980
Mixed media on paper
112.3 x 722.6 (44 x 284 1/2)
Portland Art Museum
Sandy and Adrea Bettelman Fund
Portland, Oregon

14 *Regrets*, 1981
Mixed media on paper
79.4 x 104.1 (31 1/4 x 41)
Courtesy Jack Rutberg Fine Arts
Los Angeles, California

15 *1948*, 1982
Mixed media on paper
176.5 x 87.6 (69 9/16 x 34 5/8)
Courtesy Jack Rutberg Fine Arts
Los Angeles, California

16 *The Game*, 1984
Mixed media on paper
88.9 x 120.7 (35 x 47 1/2)
Collection David and Janet Schein
Los Angeles, California

17 *Exile*, 1985
Mixed media on paper
74.9 x 57.2 (29½ x 22 1/2)
Collection Patricia Goldring Zukow
Sherman Oaks, California

18 *The Train*, 1987
Mixed media on paper
76.8 x 102.2 (30¼ x 40 3/8)
Courtesy Associated American Artists
New York City, New York

19 *The Other*, 1987
Mixed media on paper
Tondo, 56.5 (22 1/4) diameter
Collection Josephine Withers
Washington, D.C.

Prints

20 *Deposition*, 1968
Color intaglio 37/40
49.5 x 64.3 (19 5/8 x 25 1/4)
Courtesy Alice Simsar Gallery
Ann Arbor, Michigan

21 *Wendy in the Dunes*, 1969
Color intaglio and relief 2/40
35.2 x 34.3 (13 7/8 x 13 1/2)
Grand Rapids Art Museum, 69.2.13
Grand Rapids, Michigan

22 *Journey*, 1971
From the book *The Shtetl, a Journey and a Memorial*
Black-and-white intaglio 18/40
30.1 x 39.4 (11 7/8 x 15 1/2)
Collection Myron and Bobbie Levine
Ann Arbor, Michigan

23 *Moon Bone Child Stone*, 1972
Two-color lithograph 2/40
106.7 x 75.8 (42 x 29 7/8)
Collection Karl and Gloria Frankena
Ann Arbor, Michigan

24 *Disparity Among the Children*, 1975
 Four-color lithograph 17/25, State II
 75.2 x 96.5 (29 7/8 x 38)
 The Art Institute of Chicago
 Gift of Mr. and Mrs. Harold R. Flesch
 1976.106
 Chicago, Illinois

25 *Neverland*, 1976
 Two-color lithograph 5/40
 56.2 x 81.6 (22 1/8 x 32 1/8)
 The University of Michigan Museum of Art
 In memory of Joel D. Gottlieb
 Ann Arbor, Michigan

26 *Filling Up and Spilling Over*, 1976
 Black-and-white lithograph 3/8
 75.6 x 105.7 (29 3/4 x41 5/8)
 Collection Jon Levine
 San Francisco, California

27 *La Commedia è finita*, 1977
 Black-and-white lithograph 2/30
 75.2 x 94.9 (29 5/8 x 37 3/8)
 Collection Robert and Janice Richter
 San Francisco, California

28 *Fin*, 1977
 Black-and-white lithograph,
 Artist's Proof, State I
 75.2 x 105.1 (29 5/8 x 41 3/8)
 Collection Janice and Robert Richter
 San Francisco, California

29 *Elegy*, 1977
 Black-and-white lithograph 18/36
 102.3 x 75.2 (40 1/4 x 29 5/8)
 Collection Theresa Weisberg
 Los Angeles, California

30 *Second Child*, 1978
 Black-and-white lithograph 11/25
 106.1 x 75.9 (41 3/4 x 29 5/8)
 Courtesy Jack Rutberg Fine Arts
 Los Angeles, California

31 *Winter Light I and II*, 1980
 Black-and-white lithograph 23/35
 Diptych, 94.0 x 117.5 (37 x 46 1/4)
 Collection Phyllis and Sheldon Schwartz
 Bloomfield Hills, Michigan

32 *Turning Point*, 1981
 Three-color lithograph 14/26, State II
 67.3 x 89.0 (26 1/2 x 35)
 Collection Robyn Dawes and Mary Schafer
 Pittsburgh, Pennsylvania

33 *Awakening II*, 1986
 Four-color lithograph 6/22
 75.2 x 102.2 (29 5/8 x 40 1/4)
 Collection Barbara Bach Eldersveld
 In memory of Peter H. Damon
 Ann Arbor, Michigan

Dimensions are in centimeters followed
by inches; height precedes width.

Ruth Weisberg

Biography

Ruth Weisberg is professor of fine arts at the University of Southern California, and she served as chair of the Studio Art Department in 1986-87 as well as acting associate dean for the School of Architecture and Fine Arts for two years. She received her bachelor of fine arts degree in 1963 and her master of arts degree in 1964 from The University of Michigan, as well as a laurea in painting and printmaking from the Accademia di Belle Arti, Perugia, Italy. After a year at S.W. Hayter's Atelier 17 in Paris, she taught for several years at Eastern Michigan University.

Recent honors include The University of Michigan's Outstanding Achievement Award for Alumni, 1987; University of Southern California's Phi Kappa Phi Faculty Recognition Award for Creative Work, 1986; the Third Annual Vesta Award in the Visual Arts given by the Women's Building, Los Angeles, California, 1984; and the commission of a lithograph by the Graphic Arts Council, Los Angeles County Museum, 1979. In January 1979, a Weisberg lithograph was presented to Georgia O'Keeffe as part of a ceremony honoring her at the White House and in a public ceremony sponsored by the National Women's Caucus for Art. For the academic year 1969-70, Ms. Weisberg was awarded a Ford Foundation grant which was administered by the Near Eastern Center of the University of California, Los Angeles.

Selected Solo and Two-Person Exhibitions

Ruth Weisberg: Paintings, Drawings, Prints 1968-1988, Jean Paul Slusser Gallery, The University of Michigan, Ann Arbor, Michigan; DePree Art Center and Gallery, Hope College, Holland, Michigan; College of Wooster Art Museum, Wooster, Ohio; Laguna Art Museum, Laguna Beach, California—1988-1989

Associated American Artists, New York, New York—1987

The Scroll, Hebrew Union College—Jewish Institute of Religion, New York, New York—1987-1988

Jack Rutberg Fine Arts, Los Angeles, California—1983, 1985, 1988

Alice Simsar Gallery, Ann Arbor, Michigan—1968, 1969, 1972, 1974, 1977, 1988

A Circle of Life, Fisher Gallery, University of Southern California, Los Angeles, California; Hewlett Gallery, Carnegie Mellon University, Pittsburgh, Pennsylvania—1986

University of Pittsburgh, Pittsburgh, Pennsylvania—1985

Philadelphia Print Club, Philadelphia, Pennsylvania—1985

48

University of Richmond, Richmond, Virginia—1985

Judah L. Magnes Museum, Berkeley, California—1981

University of Alaska, Fairbanks, Alaska—1981

Spencer Museum of Art, University of Kansas, Lawrence, Kansas—1979

Survey Exhibition, 1971-79, Los Angeles Municipal Art Gallery, Los Angeles, California—1979

Art Gallery, Hunter College, New York—1978

Space Gallery, Los Angeles, California—1978

Santa Barbara City College, Santa Barbara, California—1978

The University of Texas at Dallas, Dallas, Texas—1978

Oglethorpe University, Atlanta, Georgia—1978

Union Gallery, Arizona State University, Tempe, Arizona—1976

Norwegian Graphic Arts Association, Oslo, Norway—1976

A.D.I. Gallery, San Francisco, California—1976

Triad Gallery, Los Angeles, California—1974

University of California, Santa Barbara, California—1974

University of Southern California, Los Angeles, California—1972

Municipal Art Gallery, Oslo, Norway—1972

Seaberg-Isthmus Gallery, Chicago, Illinois—1972

Richard Nash Gallery, Seattle, Washington—1971, 1972, 1974

Pollack Gallery, Toronto, Canada—1969, 1971

Selected Collections

Achenbach Foundation for Graphic Arts, The Fine Arts Museums of San Francisco, San Francisco, California

The Art Institute of Chicago, Chicago, Illinois

The Bibliothèque Nationale of France, Paris, France

The Dance Collection, Lincoln Center, New York, New York

Department of Rare Books and Special Collections, The University of Michigan Libraries, Ann Arbor, Michigan

The Detroit Institute of Arts, Detroit, Michigan

Downey Museum of Art, Downey, California

Eastern Michigan University, Ypsilanti, Michigan

Grunwald Foundation for the Graphic Arts, University of California, Los Angeles, California

Hebrew Union College Skirball Museum, Los Angeles, California

Houghton Library, Harvard University, Cambridge, Massachusetts

Indianapolis Museum of Art, Indianapolis, Indiana

The Jewish Museum of New York, New York, New York

Joslyn Art Museum, Omaha, Nebraska

Los Angeles County Museum of Art, Los Angeles, California

The Metropolitan Museum of Art, New York, New York

The National Gallery of Art, Washington, D.C.

The National Museum of Women in the Arts, Washington, D.C.

The New York Public Library, New York, New York

Northwestern University, Evanston, Illinois

The Norwegian National Museum, Oslo, Norway

Oakland Museum, Oakland, California

Oslo Municipal Museum, Oslo, Norway

Portland Art Museum, Portland, Oregon

The Spertus Museum of Judaica, Chicago, Illinois

Trondheim Municipal Museum, Trondheim, Norway

University Art Museum, Arizona State University, Tempe, Arizona

The University of Michigan Museum of Art, Ann Arbor, Michigan

University of Nebraska, Omaha, Nebraska

University of North Dakota, Grand Forks, North Dakota

University of Texas, Austin, Texas

Washtenaw Community College, Ann Arbor, Michigan

The William Andrew Clark Library, University of California, Los Angeles, California

Zimmerli Museum of Art, Rutgers State University of New Jersey, New Brunswick, New Jersey

Selected Bibliography Major catalogues of Ruth Weisberg's work have been published in conjunction with *The Scroll* installation, with essays by Lawrence Hoffman and Nancy Berman; *A Circle of Life* exhibition, introduction by Anne Sutherland Harris and essay by Selma Holo, 1986; the Magnes Museum exhibition, essay by Ruth Eiis, 1981; and the Barnsdall exhibition,

introduction by June Wayne, essay by Gerard Haggerty, 1979. Discussion of her art and reproductions are included in Thelma Newman's *Innovative Printmaking* (New York: Crown Publishers, 1977); Jules Heller's *Papermaking*, (New York: Watson-Guptill, 1978); and Constance Harris, *Portraiture in Prints,* (Jefferson, North Carolina and London: McFarland and Co., 1987). Major reviews and articles on Ruth Weisberg include:

"Talk of the Town," *The New Yorker,* November 23, 1987.

"Ruth Weisberg at U.S.C.," Peter Clothier, *Art in America*, April 1986.

"The Universal and the Particular," Betty Ann Brown, *Artweek*, Los Angeles, February 22, 1986.

"Two Exhibitions that Show and Tell," Suzanne Muchnic, *Los Angeles Times*, February 18, 1986.

"Ruth Weisberg: Transcendance of Time Through Persistence of Imagery," Gilah Yelin Hirsch, *Women's Art Journal*, Fall 1985/Winter 1987.

"Cradled in the Legacy of the Holocaust," Barbara Isenberg, *Los Angeles Times*, October 5, 1985.

"Autobiographical Journey," Ora Lerman, *Arts Magazine*, May 1985.

"Art and Life," Roy Proctor, *Richmond News Leader*, February 23, 1985.

"Prints, Drawings at Marsh Gallery," Robert Merritt, *Richmond Times Dispatch*, February 22, 1985.

"Ruth Weisberg," Melinda Wortz, *Art News*, January 1984.

"Ruth Weisberg," Gilah Yelin Hirsch, *Images and Issues*, January/February 1984.

"Ruth Weisberg," Betty Brown, *Arts*, September 1983.

"Ruth Weisberg: Dream and Fantasy," Mac McCloud, *Artweek*, October 8, 1983.

"Movies as Modern Muse," Gerard Haggerty, *LAICA Journal,* Summer 1982.

"Past and Presence, Responses to Tradition," Suzaan Boettger, *Artweek*, February 28, 1981.

"Venice, California," Gordon J. Hazlett, *ArtNews,* January 1980.

"Collected Histories," Maudette Ball, *Artweek*, November 27, 1979.

"Artists: Layers of Real, Unreal," Suzanne Muchnic, *Los Angeles Times*, November 8, 1979.

"Two Paths for Technique," Louise Lewis, *Artweek*, July 29, 1978.

"New and Old Blend," Jean Paul Slusser, *Ann Arbor News*, February 27, 1977.

Publication © Regents of The University of Michigan 1988
All rights reserved.

Library of Congress
Catalog Card Number: 88-50068
ISBN 0-935312-96-X

Co-published 1988 by
The University of Michigan School of Art
2000 Bonisteel Boulevard
Ann Arbor, Michigan 48109-2069

and
The Feminist Press
at The City University of New York
311 East 94th Street
New York, New York 10128

Distributed by
The Talman Company
150 Fifth Avenue
New York, New York 10011

Colophon Catalogue Design by
Laura A. Clemente

Typography in Sabon 10/12 by
Doug Hagley, Kolossos Printing
Ann Arbor, Michigan

Printed by
Grigg Graphic Services
Detroit, Michigan

Photography by
Kenna Love Photographic
Van Nuys, California

Color Separations by
Precision Color Plate
Plymouth, Michigan

"[Ruth] Weisberg brings to her art not only an exceptional artist's hand and eye but also great intelligence and a moral commitment to spiritual values and to the power of art to communicate them." — *Ann Sutherland Harris*, Professor of Art History, University of Pittsburgh

"Weisberg's is an art of affirmation." — *June Wayne*, Artist

"This body of work is an act of passage. In her use of both form and content, technique and iconography, Weisberg is one of those contemporary artists who are reshaping the pictorial language of the male-dominant culture." — *Thalia Gouma-Peterson*, Professor of Art History, The College of Wooster

"Concerned with the redemptive value of art, Ruth [Weisberg] seeks the wholeness that encompasses both the pains and joys of living — and of dying. In her work, we are constantly reminded that dying is part of living . . . passing is part of permanence, exit is part of entrance, and the finite is part of the infinite. [Her] struggle is the human struggle in which we all engage." — *Marion E. Jackson*, Associate Dean, The University of Michigan School of Art

The Feminist Press The University of Michigan School of Art
at The City University of New York Printed in USA
Distributed by The Talman Company ISBN 0-935312-96-X

DATE DUE

MAR 24 1992			
MAR 28 1992			
GAYLORD			PRINTED IN U.S.A.